11.7.22

Dippy

the tale of a museum icon

ISBN 13 978-0-565-09259-7

10 9 8 7 6 5 4 3

Designed by David Mackintosh (www.davidmackintosh.co.uk)
Reproduction by Saxon Digital Services
Printing by Printer Trento Srl, Italy

Find out more about Publishing
at the Natural History Museum
www.nhm.ac.uk/publishing

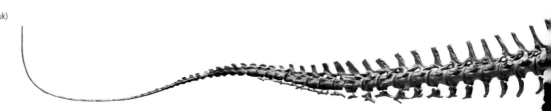

A star cast (overleaf)
The Museum's *Diplodocus*
skeleton cast, known
affectionately as Dippy, was
for many years the first sight
to greet Museum visitors.

Dippy

the tale of a museum icon

Paul Barrett, Polly Parry
& Sandra Chapman

Published by the

Natural History Museum, London

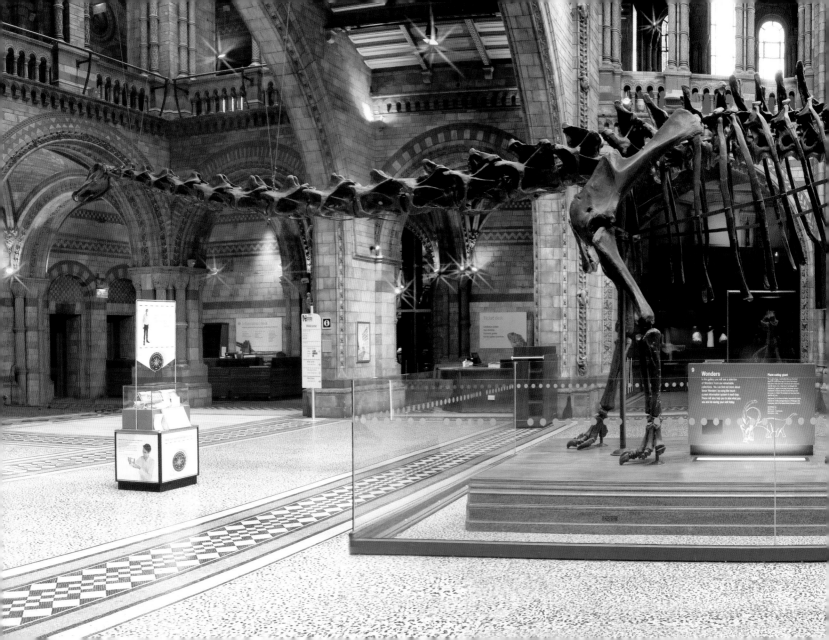

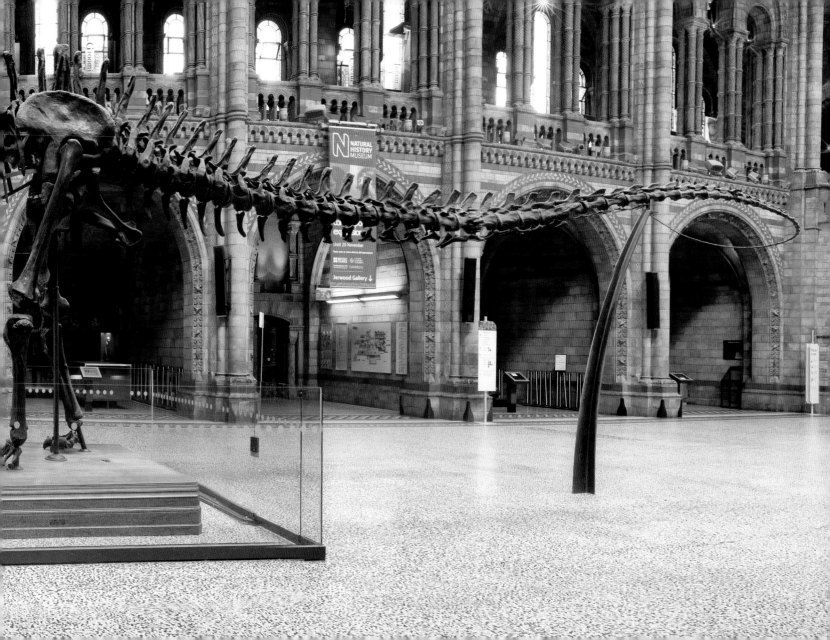

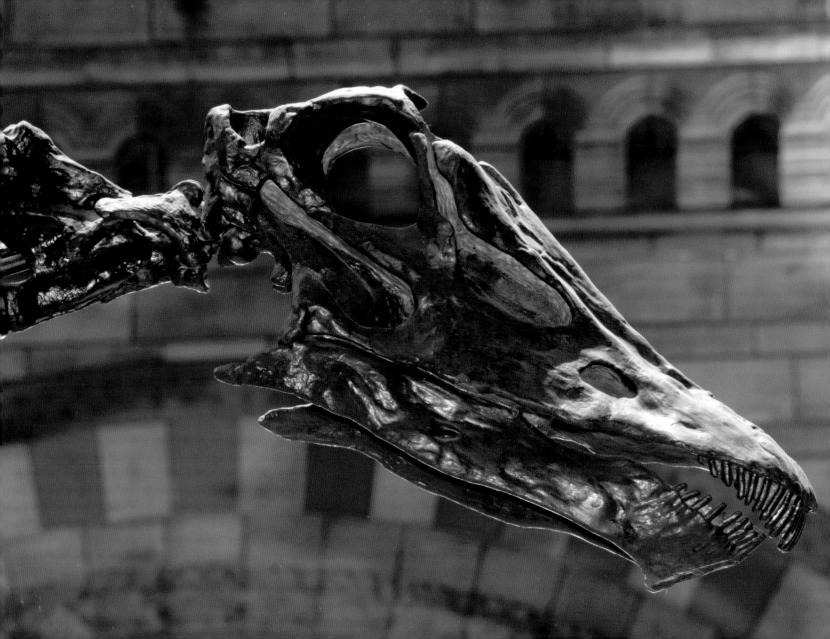

Introduction

The eerie, buck-toothed grin of *Diplodocus* greeted visitors of the Natural History Museum, London for over 100 years. Known affectionately as 'Dippy' among the Museum's staff, the imposing skeleton of this massive dinosaur towered over all who saw it. Dippy is not a real skeleton, however, but an exact plaster replica of fossilised bones found in the badlands of Wyoming, USA, and now housed in the Carnegie Museum of Natural History, Pittsburgh. The London *Diplodocus* was first revealed to an astonished public in 1905 and became an instant media star, depicted in numerous newspaper cartoons and news reports. Dippy continues to enthral the public and has even had a starring role in movies and TV shows. A special exhibition was held to celebrate its centenary at the Museum in 2005.

The story of how *Diplodocus* came to the Natural History Museum is one that involves danger and adventure in the harsh environment of the American Wild West, the generosity of an eccentric millionaire and the involvement of the British royal family. It is also a tale of scientific discovery: Dippy's appearance has changed through the years, reflecting advances in our understanding of dinosaur biology and evolution. Although Dippy is over 100 years old, this fantastic object continues to provide new inspiration, challenging us to look ever more deeply into the past.

Visitors to the Natural History Museum often ask: 'What is the correct way to pronounce *Diplodocus*?' As the name is a combination of two Greek words, it should sound like '*dip*-low-*dock*-us' with the emphasis on the 'dip' and 'dock'. However, there are lots of variations on this, ranging from '*dip*-low-*doe*-cus' to '*dip*-*lod*-oh-cus'. Another common question is: 'How many bones does Dippy have?' If you ignore the teeth and count the skull and lower jaw

An eerie grin
Diplodocus stared out across the Hintze Hall of the Natural History Museum from 1979 to 2016. Dippy has been one of the Museum's most iconic exhibits.

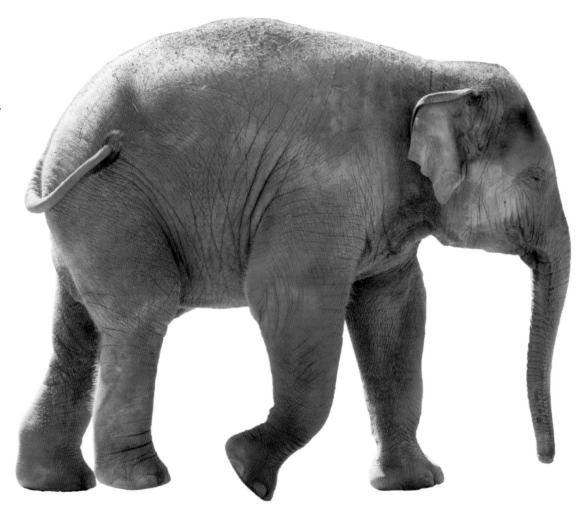

An upright stance

Mammals, such as this Indian elephant, have their legs tucked directly beneath the body. The legs act as pillars and this is a very efficient way to support weight.

as a single structure, the total comes to 292. There are over 70 tail vertebrae and the hands and feet also contain nearly 60 finger and toe bones. However, skulls are complex structures made up of many individual bones – if these are all taken into account the number increases to an impressive 356. There are also 46 teeth, a number that varies slightly between different *Diplodocus* skulls.

A sprawler

Most reptiles, like this crocodile, have legs that stick out from the side of the body, which makes it harder to hold their bodies up off the ground.

Discovering dinosaurs

During the early part of the nineteenth century, discoveries of large fossil bones were made in the quarries and coastlines of southern England. Gideon Mantell, a country doctor from Lewes, Sussex, and Reverend William Buckland, a geologist at Oxford University, studied these specimens and soon realised that the remains represented new kinds of extinct reptiles, the like of which had never been seen before. They named these animals *Megalosaurus* ('great lizard'), *Iguanodon* ('iguana tooth') and *Hylaeosaurus* ('forest lizard'). These were the first dinosaurs to be described scientifically anywhere in the world.

Initially, Mantell, Buckland and their colleagues thought that these new species were nothing more than gigantic versions of lizard-like animals. However, in his studies of the fossil bones, the anatomist Sir Richard Owen noted something unusual about the skeletons. Owen, who went on to become the first Director of the Natural History Museum, recognised that the three animals shared a series of features not seen in any other reptiles, living or extinct. In particular, he saw that they all possessed legs that were tucked

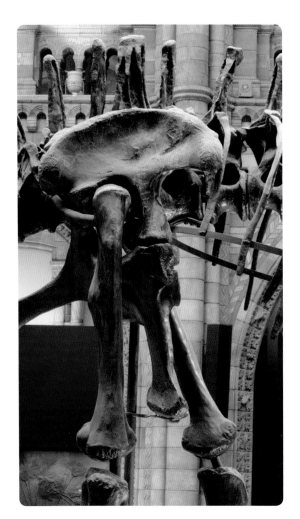

directly under the body, as in mammals. Like those of an elephant, the legs resembled strong pillars that provided the animal with a lot of support. This was in contrast to the way that most other reptiles, like lizards and crocodiles, held their legs. These other reptiles had legs that stuck out from the sides of the body, giving them more of a waddle as they walked. Other differences included the way in which the hipbones were connected to the backbone. In most reptiles, the hipbones attach to just two vertebrae, but in *Megalosaurus*, *Iguanodon* and *Hylaeosaurus* they attach to at least three vertebrae, making a much stronger link. Owen decided that these features of the legs and hips were sufficiently important to place *Megalosaurus*, *Iguanodon* and *Hylaeosaurus* in a new group. In 1842, he published a paper describing his findings in detail and suggested a name for this new group – the Dinosauria, meaning 'terrible lizards'.

The following years witnessed the discovery of many new types of dinosaurs in England, France and Germany. However, most of these early finds were of individual bones or incomplete skeletons that did not give a clear picture of what the animals actually looked like. This lack of information led to some mistakes in early reconstructions of dinosaurs, the most famous of which are the large models that can still be seen standing in Crystal Palace Park, southeast London. These models were created by the sculptor Benjamin Waterhouse Hawkins between 1852 and 1854 and were designed in close consultation with Richard Owen, so they represent accurate reflections of mid-

nineteenth-century scientific thought. At the time it was believed that dinosaurs walked on all fours (quadrupedal) and essentially looked like reptilian versions of large mammals, such as rhinos. The models reflect this – *Megalosaurus* and *Iguanodon* are both shown in quadrupedal stances. Although this differs radically from modern reconstructions of these animals (both *Megalosaurus* and *Iguanodon* are now known to have walked bipedally, on their hind legs), the Crystal Palace models were as accurate as they could have been, given the specimens that Owen had to hand.

However, it was not long before exciting new discoveries in the USA began to challenge Owen's vision. During the 1800s thousands of settlers headed out into the American west in search of new homes. As they did, the explorers, farmers and engineers made stunning fossil finds, including the first complete dinosaur skeletons. This scientific bonanza sparked fierce competition among scientists, who began frantic searches for new and more spectacular dinosaur species. The most famous rivalry developed between Professor Othniel C. Marsh of Yale University and Professor Edward D. Cope of the National Academy of Sciences in Philadelphia. Both men funded dozens of expeditions to the American badlands of Colorado, Wyoming and Montana during the 1860s to 1880s in an attempt to upstage each other. At times the rival teams would meet by accident while searching for fossils and in some cases fistfights and even gunfights would break out. As a result, the intense competition between Marsh and Cope has often been termed the 'Bone Wars'. During this period both men named dozens of new dinosaur species, many of which are still familiar today.

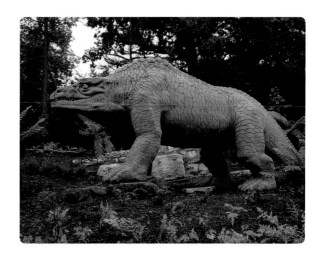

Dinosaur legs
The legs of *Diplodocus* (opposite), and all other dinosaurs, are constructed in a way very similar to that of mammals, with massive hip bones. The models in Crystal Palace Park such as this *Megalosaurus* (above), show how dinosaurs were envisioned at the time of Sir Richard Owen.

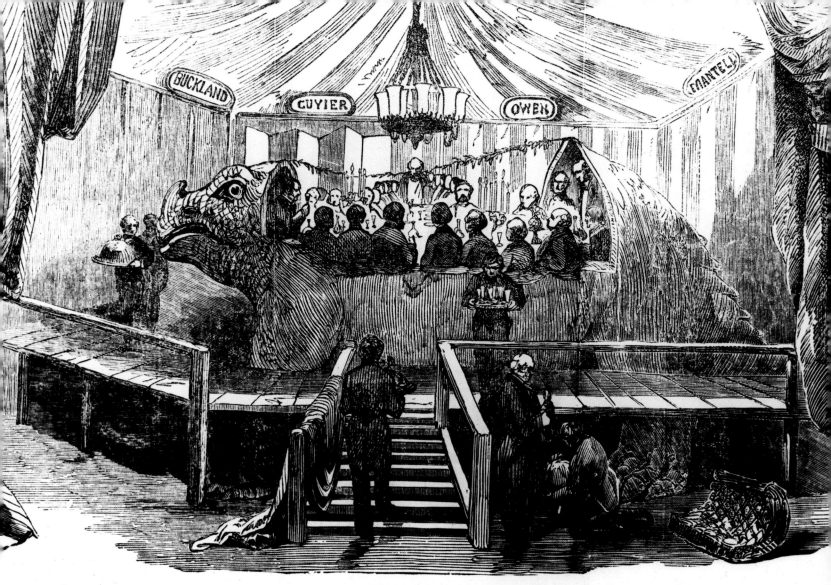

BUCKLAND

CUVIER

OWEN

MANTELL

DINNER IN THE IGUANODON MODEL, AT THE CRYSTAL PALACE, SYDENHAM.

Enter Diplodocus

In 1878, Marsh described a new type of dinosaur whose remains had been unearthed near the small town of Cañon City, Colorado. Benjamin Mudge, one of Marsh's regular bone collectors, had unearthed the skeleton in 1877. It was not complete, but included one of the hind legs, a section of the hip and the tail. Marsh noted that the small bones running along the underside of the tail were different in shape from those of any other dinosaurs. These bones, termed the chevrons, are responsible for protecting the bundles of nerves and blood vessels running through the tail. This difference led Marsh to propose a new name for the skeleton, *Diplodocus longus*. The name *Diplodocus* means 'double-beamed' and refers to the structure of the chevrons, which have two branches (one pointing forward and one pointing backward), rather than the single, backward-pointing branch seen in other reptiles. Many other specimens of *Diplodocus* have now been found, ranging from whole skeletons to finds of just a few bones or teeth, enabling palaeontologists to build up a complete picture of this animal. All known skeletons of *Diplodocus* come from the states of Colorado, Montana, New Mexico, Utah and Wyoming in the American west. None have been found anywhere else in the world.

Belly of a dinosaur
Following completion of the Crystal Palace dinosaurs, Sir Richard Owen famously hosted a dinner within the *Iguanodon* model, an event reflecting the enormous popular impact of early dinosaur discoveries.

Diplodocus specimens all come from a thick band of sandstones and mudstones termed the Morrison Formation, which covers over one million square kilometres of the western USA. These are some of the most productive dinosaur-bearing rocks in the world, for two reasons. Firstly, the rocks were laid down by a set of ancient rivers crossing a wide, forested plain that was home to thousands of dinosaurs. Secondly, the rocks of the Morrison Formation are found at the surface over large areas, meaning that there are lots of opportunities to find fossils. These rock layers have produced the remains of many famous dinosaur species, including the large meat-eater *Allosaurus*, the plated *Stegosaurus* and the placid plant-eater *Camptosaurus*. Rocks of the Morrison Formation have been dated to the Late Jurassic period, so all of these dinosaurs, including *Diplodocus*, would have lived some time between 157 and 145 million years ago.

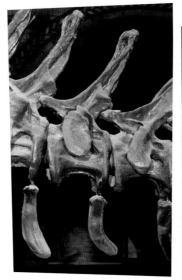
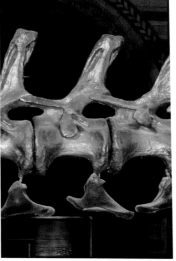

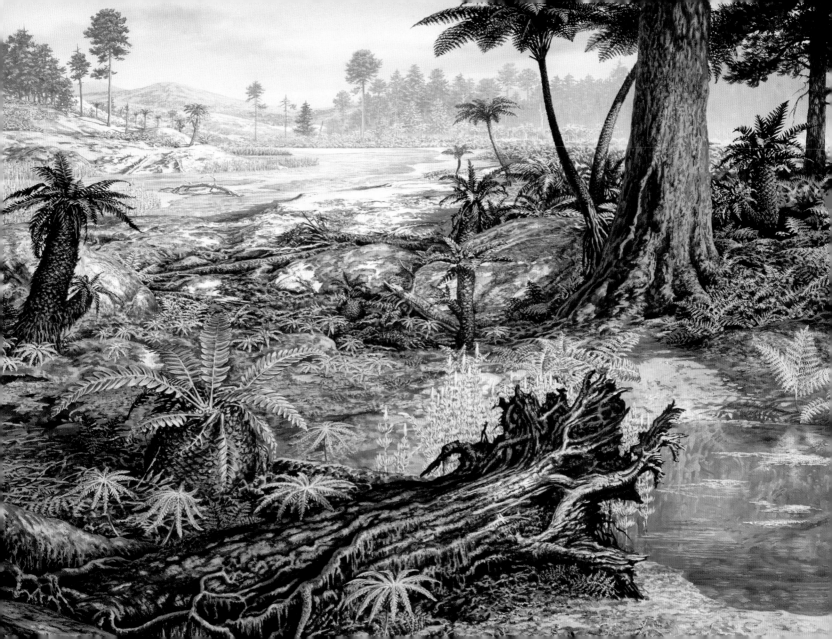

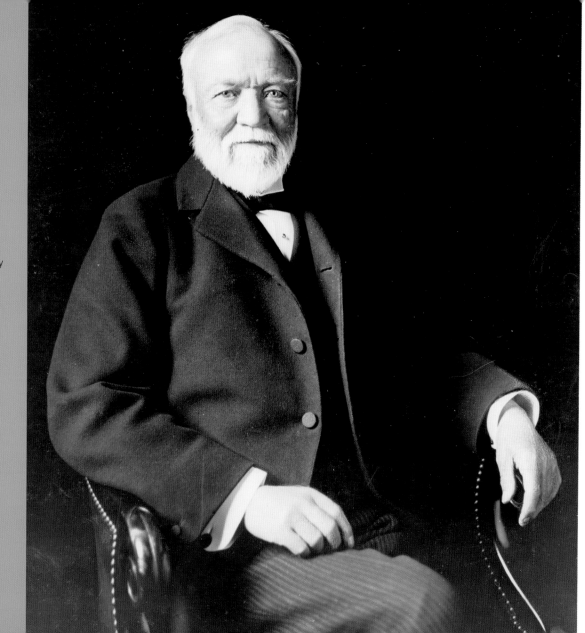

Andrew Carnegie
Multi-millionaire Andrew Carnegie (1835–1919), the man whose immense wealth and society connections brought Dippy to the Natural History Museum, London.

Mr Carnegie's dinosaur

The most important person in Dippy's history was Andrew Carnegie, a Scottish-born businessman whose family emigrated to the USA when he was 12 years old. Although Carnegie came from a modest background (his father was a weaver and his mother a cobbler), he worked his way through a wide variety of trades to amass a vast personal fortune, particularly through his interests in the steel industry. He became one of the world's richest men and divided his time between Pittsburgh, USA – the city where his factories, mills and businesses were based – New York and the UK. In his later years, Carnegie donated large sums of money to various educational and cultural projects, the grandest of which was a vast museum, the Carnegie Institute (now the Carnegie Museums), which he established in Pittsburgh in 1895. Carnegie enthusiastically set about the task of finding spectacular exhibits with which to fill the galleries – with no expense spared.

In 1898, William H. Reed, a railroad engineer and fossil collector working in the badlands near Sheep Creek, Wyoming, found parts of a gigantic dinosaur skeleton. News of this discovery reached American telegraph agencies and was soon splashed across the pages of the *New York Journal and Advertiser* and other major newspapers, billed as the 'Most colossal animal ever on Earth'. Carnegie was captivated by the story and quickly decided that this would be an ideal centrepiece for his new museum. He contacted the museum director, Professor William

Diplodocus unearthed

A photograph showing William Reed in the Sheep Creek quarry, excavating the bones of what would become *Diplodocus carnegii*.

J. Holland, instructing him to do all that he could to acquire the skeleton. Holland agreed and was soon heading out to the wild landscapes of Wyoming to meet with William Reed, and begin the delicate negotiations that were needed to secure the prize. After many false starts and disputes over ownership, the skeleton, which was identified as *Diplodocus* by Holland, was finally excavated during the summer of 1899. It reached the museum in Pittsburgh later that year along with a second, smaller *Diplodocus* skeleton that had been found at the same site.

Once at the museum, the laborious process of removing the fossil bones from the rock began, a task accomplished by a talented team of scientists and technicians. The scientific description of the new skeleton fell to Holland's new assistant Dr John Bell Hatcher, a palaeontologist who had previously spent time collecting for Marsh. Hatcher produced a detailed, weighty scientific paper on the main skeleton, which was published in 1901. The skeleton was almost complete, missing only the skull, parts of the limbs and a section of the tail. Although the paper was already lavishly illustrated, Hatcher decided to produce a complete restoration of the skeleton to show the animal in all its glory. Missing bones were reconstructed by using other *Diplodocus* skeletons as a guide. During his studies, Hatcher noticed that his new *Diplodocus* showed a number of subtle differences in the shapes and sizes of the bones from the other *Diplodocus* skeletons that Professor Marsh had described a few years beforehand (which Marsh had named *Diplodocus longus* and *Diplodocus lacustris*). Hatcher considered that these differences were important enough to recognise his *Diplodocus* as a new species, which he named *Diplodocus carnegii* in honour of his employer.

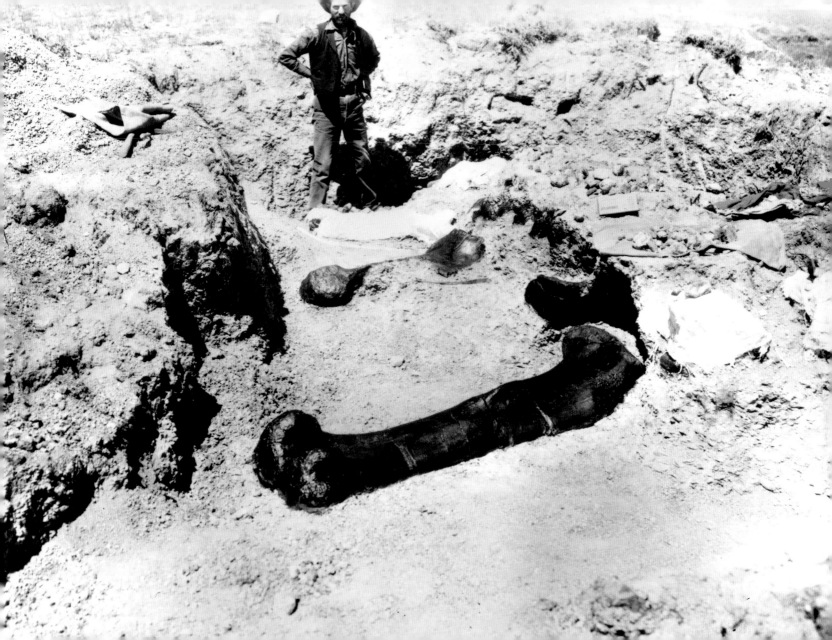

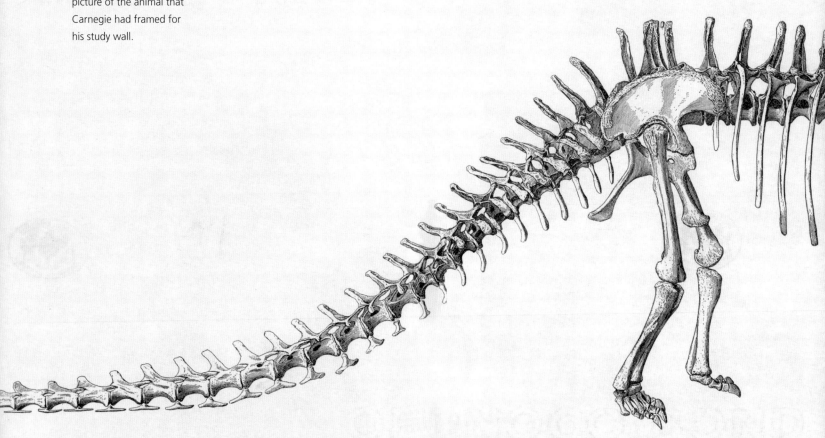

A monstrous vision
John Bell Hatcher's famous
reconstruction of the
complete *Diplodocus*
skeleton. This is the
picture of the animal that
Carnegie had framed for
his study wall.

PLATE XIII.

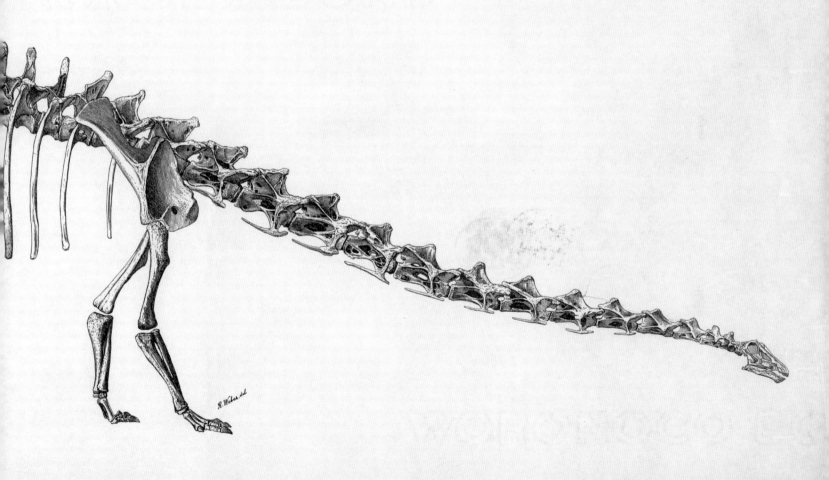

R. Weber. del.

A royal intervention

Carnegie often spent time at his Scottish castle, Skibo, and was not in Pittsburgh when Hatcher's paper was published. Knowing of his intense interest, Holland sent Carnegie a framed print of the restored *Diplodocus carnegii* skeleton. Carnegie was delighted and had the print mounted on the wall of his study.

Letter from Carnegie

In October 1902, Carnegie wrote to his curator in Pittsburgh, Professor William Holland, about King Edward VII's wish to obtain a *Diplodocus* to display in London.

In the autumn of 1902, King Edward VII visited Carnegie at Skibo. While chatting in the study, the King spotted the print and asked what it was. Carnegie explained that he had acquired this animal for his new museum in Pittsburgh and that it had been named in his honour. Suitably impressed, the King remarked on how marvellous it would be to have such an animal housed in the galleries of the British Museum (now the Natural History Museum). An excited Carnegie took the King's comment to heart and quickly scribbled a note to Holland back in Pittsburgh: 'The King was attracted to the *Diplodocus* when here. He wants one for [the] British Museum badly. I read your note, which told of the new finds. He is on your track now for duplicates. Maybe you [should] call upon him when you come to us next time.'

Holland dissuaded Carnegie from attempting to find and excavate another *Diplodocus* skeleton, as he did not know of any new finds that would match the skeleton they had recently spent so much time and effort in collecting. However, he did suggest that it might be possible to make an accurate cast instead. Carnegie threw his support behind the idea and told Holland to begin work. In December 1902, Holland made a formal offer of a cast to the Director of the Natural History Museum, Professor Edwin Ray Lankester, emphasising its accuracy. He wrote 'the whole to be executed in the very highest style of art and so prepared as to be capable of being easily mounted and displayed'. In early 1903, three expert Italian model-makers were

TELEGRAMS, CLASHMORE.
STATION, BONAR BRIDGE.

Oct 2 1902
SKIBO CASTLE,
DORNOCH,
SUTHERLAND.

My Dear Curator,

Yours of 28th Aug
has given me unusual
pleasure.

The King was attracted
to the Diplodocus
when here. He wants
one for British Museum
badly. I read your
note which tells

of the new find. He
is on your track
now for duplicate.
Maybe you call upon
him when you come to
us next time,

We are closing
for season. Madam &
I start in ten days
thumping tour.
Set funds for me

two for her. Speeches, speeches,
speeches. Madison later. Sail
Nov 19th very late. See
you all too soon I
hope.

Yours
Ever
Andrew Carnegie

Letter From Holland
Extracts from Professor Holland's letter to the Director of the Natural History Museum, dated June 1904, informing him that the cast is nearing completion.

CARNEGIE MUSEUM, 23.

COM. 23 JUL. 1904

(DEPARTMENT OF THE CARNEGIE INSTITUTE.)

PITTSBURGH, PENNSYLVANIA, U. S. A.

J. HOLLAND, PH. D., LL. D., DIRECTOR.

SS ALL CORRESPONDENCE TO THE DIRECTOR.

BRITISH MUSEUM
NATURAL HISTORY.

1575¹
P
20 JUN 1904

June 10, 1904.

Dr. E. Ray Lankester,

Director of the British Museum (Natural History),

Cromwell Road, S.Kensington, London, S.W.,

England.

My Dear Professor Lankester;-

As you will recall, on the 23d of February, 1903, the Trustees of the British Museum accepted an offer from Mr. Andrew Carnegie, tendered by me through you, to construct for your Museum a reproduction of the skeleton of Diplodocus. I now write to inform you that the work of reproducing this great skeleton is rapidly nearing completion, and Mr. J. B. Hatcher, our Curator of Paleontology, informs me that he will be ready to pack the specimen and ship the same about the middle of July. Mr. Carnegie has instructed me to arrange for the making of the bases in a style approved by you and to provide all the of setting up the specimen wherever you may designate.

employed to mould and cast the bones and to make models of the missing bones based on other *Diplodocus* specimens in the collections of the Carnegie Museum. In early 1904, additional men were also taken on to help with this colossal task. Each replica bone was made out of plaster-of-Paris and painted black to look like the real fossils. This work continued until the summer of 1904, when all of the casts had been completed. Dippy is based mainly on one specimen, the original skeleton of *Diplodocus carnegii* (which has the Carnegie Museum [CM] catalogue number CM 84). Missing parts of the limbs were based on the smaller *Diplodocus* skeleton found at Sheep Creek (CM 94) and the tail from a third specimen (CM 307). The skull was copied from a specimen that Marsh had described some years earlier, which is housed in the National Museum of Natural History (part of the Smithsonian Institution in Washington, DC). The skull was completed with some information from a second, broken skull found at Sheep Creek (CM 662). As a result, Dippy actually represents not one *Diplodocus*, but five.

" The skeleton, I may say, when mounted will be between 78 and 80 feet in length from the tip of the nose to the end of the tail. The neck is raised as we are mounting the specimen, and not lowered as in the drawing I sent you some time ago and as published "

" The tail is very long and tapers at the end to a point where the vertebrae are not much thicker than the little finger of a man. "

" We wish to have the pleasure of installing and completing this gift subject to your approval and direction in the handsomest manner possible. Mr. Carnegie, as you are well aware, does not do things by halves, and as he is making the gift at the suggestion of his Majesty, King Edward VII, he is very particular that everything shall be done in the best possible manner. "

Dippy at large

The casts were dispatched in December 1904 in a huge shipment of 36 packing cases. They arrived at the Natural History Museum in January 1905 and the following month Holland and his chief laboratory technician, Arthur Coggeshall, arrived in London with a team of American technicians to begin work on mounting the skeleton. Dippy's first home in the Museum was the Reptile Gallery (now the Human Biology Gallery), as there was no space for the huge skeleton in the more appropriate, but full, Fossil Reptile Gallery (now the Creepy Crawlies Gallery). Mounting the heavy plaster casts and bolting them on to the specially constructed cast-iron frame was difficult and, at times, nail-biting work, but proceeded without accident. Finally, the mount was complete and Dippy became the first full skeleton of a sauropod dinosaur to be placed on display anywhere in the world.

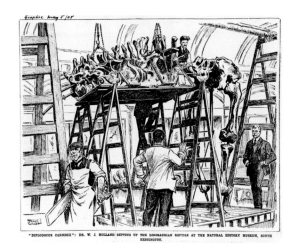

"DIPLODOCUS CARNEGII": DR. W. J. HOLLAND SETTING UP THE DINOSAURIAN REPTILE AT THE NATURAL HISTORY MUSEUM, SOUTH KENSINGTON.

At 1pm on Friday 12 May 1905, Dippy was officially unveiled at a lavish presentation ceremony held in the Reptile Gallery. Andrew Carnegie was guest of honour and Lord Avebury accepted the gift on behalf of the Museum. Carnegie, Avebury, Lankester, Holland and others made a series of speeches to a crowd of 300 people gathered around the feet of the skeleton, representing the British scientific and social élite. In his speech, Lankester made some comparisons between *Diplodocus* and an English dinosaur, *Cetiosauriscus*, whose remains are housed in the Natural History Museum and were on display nearby. He joked that '*Diplodocus* is an improved and enlarged form of an English creature … not quite as large as *Diplodocus*, but in measure a rival'. Lord Avebury remarked: 'The name *Diplodocus* would not till a

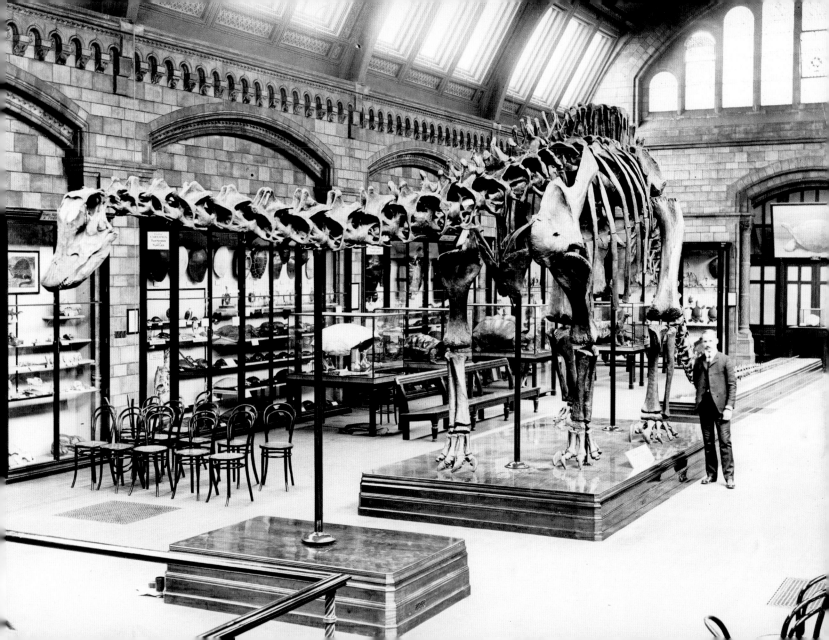

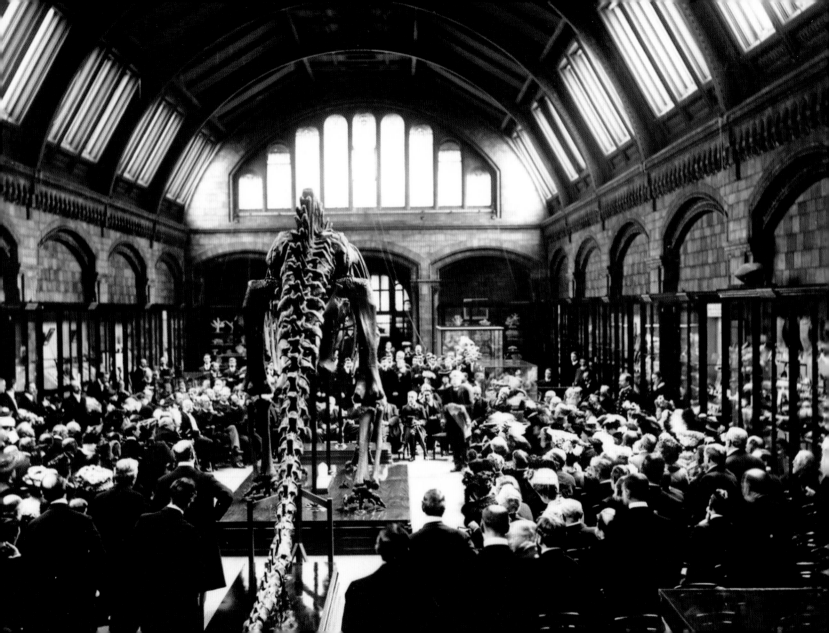

few days ago have conveyed much to … our countrymen, but the sight of this skeleton will not fail to impress them.' He went on to praise Carnegie for his 'splendid gift'. Sadly, although it was his request that resulted in Dippy's arrival at the Museum, the King declined to attend the ceremony. His Majesty could 'hardly undertake to perform the ceremony', but was 'sure that the skeleton must be a very interesting one, and [he was] very glad to hear that Carnegie [was] going to present it to the British Museum'.

The British public were captivated with the new exhibit and flocked to the Museum to see it. Dippy became a media star. Headlines like 'Welcome colossal stranger' and 'The greatest animal that ever lived' ran in *The Times*, the *Daily Express* and many other newspapers. Dippy was appropriated by several newspaper cartoonists, not only in sketches of Museum life, but also for political cartoons. More recently, Dippy was the inspiration behind the 1975 Walt Disney film *One of Our Dinosaurs is Missing*, and has starred in numerous TV shows.

The unveiling
Lord Avebury making a speech at the formal presentation ceremony in the Reptile Gallery, 12 May 1905.

A media star
The inspiration that Dippy provided for newspaper cartoonists can be seen in these examples from the *Morning Leader* (left) and *The Star* (right).

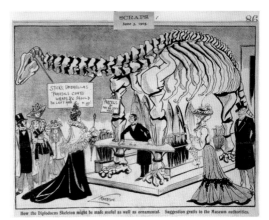

How the Diplodocus Skeleton might be made useful as well as ornamental. Suggestion gratis to the Museum authorities.

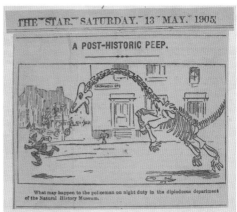

What may happen to the policeman on night duty in the diplodocus department of the Natural History Museum.

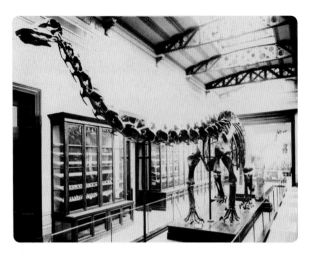

Diplodocus abroad
Another *Diplodocus* cast that was mounted in 1912 in the Exhibition Hall of the Museo de La Plata, Argentina.

Carnegie's generous donation sparked a reaction from many other museums around the world, all of which clamoured for a cast of their own, often with the enthusiastic backing of royal patrons. Ever the philanthropist, Carnegie presented copies to natural history museums in Paris, Berlin, Vienna, Bologna, St. Petersburg (now in Moscow), La Plata and Madrid – all of which are still on public display. Other casts made from the same moulds were later purchased for display in Mexico City and Munich, though the latter has never been mounted.

Ironically, the original skeleton of *Diplodocus carnegii*, which can still be seen today at the Carnegie Museum of Natural History in Pittsburgh, was not put on public display until 1907, two years after Dippy had been exhibited in London. This was due to major problems they had in building supports strong enough to cope with the incredible weight of the fossilised bones.

During its time at the Natural History Museum in London, Dippy has moved around as the exhibitions have been changed. Dippy remained in the Reptile Gallery until 1931, when it was transferred to the Fossil Reptile Gallery. During the Second World War, Dippy was disassembled and placed in the Museum's basement to limit the possibility of damage during the bombing raids on London. In 1979 Dippy moved to occupy a place of honour in Hintze Hall, where it remained for many years until 2016, greeting visitors entering through the Museum's main entrance. From early 2018, the iconic exhibit is going on display at indoor venues throughout the UK. In addition to this spectacular cast, the Natural History Museum also has some real *Diplodocus* vertebrae, kept in the research collections of the Earth Sciences Department.

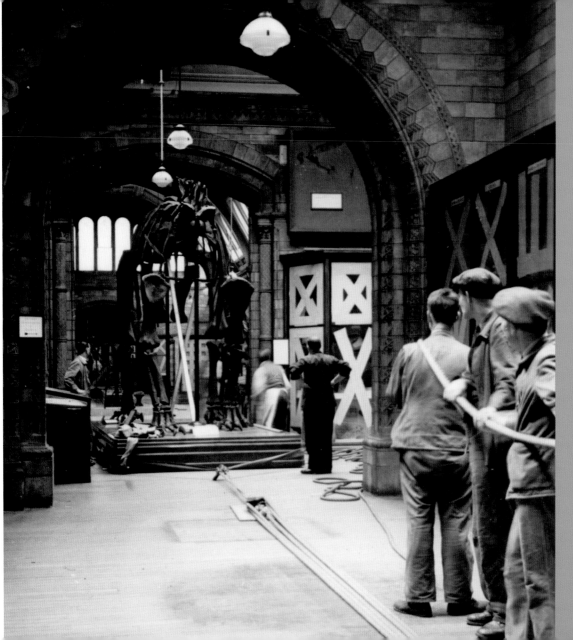

Wartime removal
To protect Dippy from
the bombs falling on
London during the Second
World War, the cast
was dismantled in April
1940 and moved to the
basement of the Museum.

Diplodocus as a dinosaur

Diplodocus belongs to a group of dinosaurs known as the sauropods, meaning 'lizard feet'. Other members of this group include *Apatosaurus*, *Brontosaurus* and *Brachiosaurus* (one of the stars of the *Jurassic Park* movies). Sauropods are all characterised by their extremely long necks (which can contain up to 17 individual vertebrae), barrel-shaped bodies with thick, pillar-like legs and long, slender tails. Their heads are very small in relation to their body size. Sauropods include the largest land animals of all time, such as *Argentinosaurus*, which would have weighed a stupendous 70 tonnes (about the same as ten fully grown male African elephants). At the time of its discovery, *Diplodocus* was one of the largest sauropods known. It is still one of the longest: Dippy is around 26m in length, which is pretty impressive, but really large *Diplodocus* individuals reach up to 33m. However, it was relatively lightly built (for a sauropod) and probably weighed in at around 20 tonnes. All sauropods were plant-eating animals (herbivores) and would have had to consume hundreds of kilograms of leaves and other vegetation each day in order to fuel their enormous bodies.

Building a sauropod

All sauropods are characterised by a very small head, long neck and barrel-shaped body. Over 120 different kinds of sauropod have been named.

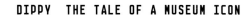

Sauropod fossils have been recovered from every continent (with the exception of Antarctica) and first appeared on Earth during the Late Triassic period, around 220 million years ago. They became more widespread and abundant during the following Jurassic Period (201–145 million years ago) and also lived throughout the Cretaceous Period (145–66 million years ago), though they were less common at this time than during the Jurassic. Sauropods finally became extinct at the end of the Cretaceous Period, disappearing at a time when all other dinosaurs (with the exception of their descendants, the birds) and many other types of plants and animals also became extinct.

On land or water?

Scientists at the time of Cope, Marsh, Hatcher and Holland thought that all sauropods, including *Diplodocus*, were amphibious, slow-moving animals that spent most of their time submerged in rivers and lakes. This idea was based on various pieces of evidence. Firstly, it was thought that the sheer weight of sauropods would have made walking around on land too difficult – their legs were viewed as too weak to support the huge bulk of the body. It was argued that if they lived in rivers and lakes this would be less of a problem, as the water would buoy them up. In addition, many of the bones, or vertebrae, that make up the backbone in sauropods are hollow and some palaeontologists suggested that these hollows were filled with air sacs when the animals were alive. These might have helped the animals to float about while submerged. Secondly, the very long necks of sauropods were thought to be adaptations to an aquatic lifestyle, for two reasons. These would have allowed sauropods to reach vegetation growing along the banks without having to leave the water and, more importantly, the long necks (up to 11m long in the case of the Chinese sauropod *Mamenchisaurus*) could

An amphibious Diplodocus?

Early reconstructions of *Diplodocus* and other sauropods placed them in rivers and lakes. However, we now know that *Diplodocus* and its relatives spent most of their time on dry land.

have been used like snorkels, keeping the animal's head above water, while it walked along deep riverbeds. The snorkel idea was also backed up by the peculiar structure of the sauropod skull. In all sauropods, the nostrils are not on the front of the face, but are positioned further back towards the eyes. In *Diplodocus*, and many other sauropods, the nostrils are actually placed right between the eyes, almost on top of the head! Many early reconstructions showed sauropods almost completely submerged with only their eyes and nostrils poking above the level of the water in a crocodile-like manner. Finally, the jaws and teeth of many sauropods were thought to be too weak to chew tough leaves and twigs, so it was suggested that they might have lived on a diet of soft water-loving plants, such as algae and ferns.

More recent work has shown that most of these ideas are wrong. The legs of sauropods are very robustly built and acted as very strong pillars that would easily have supported the weight of the body. Indeed,

DIPPY THE TALE OF A MUSEUM ICON

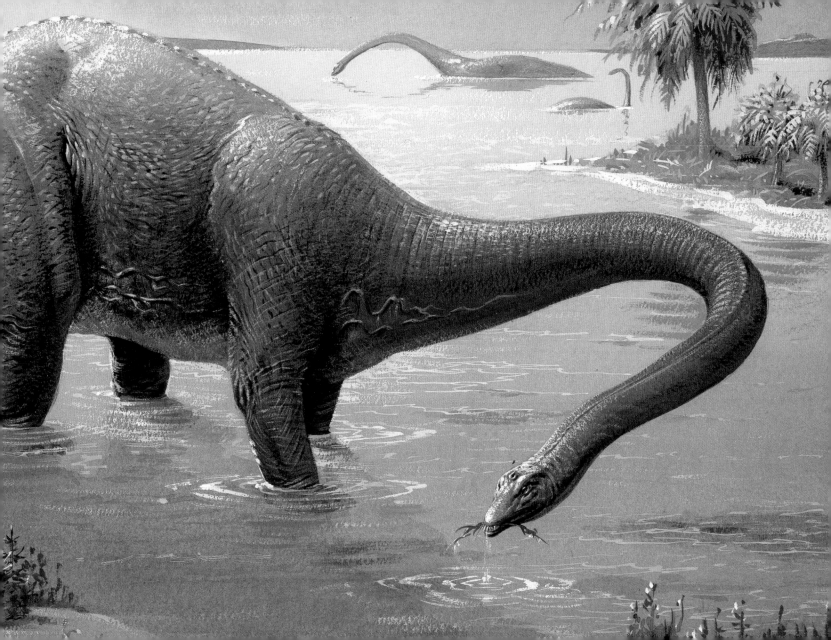

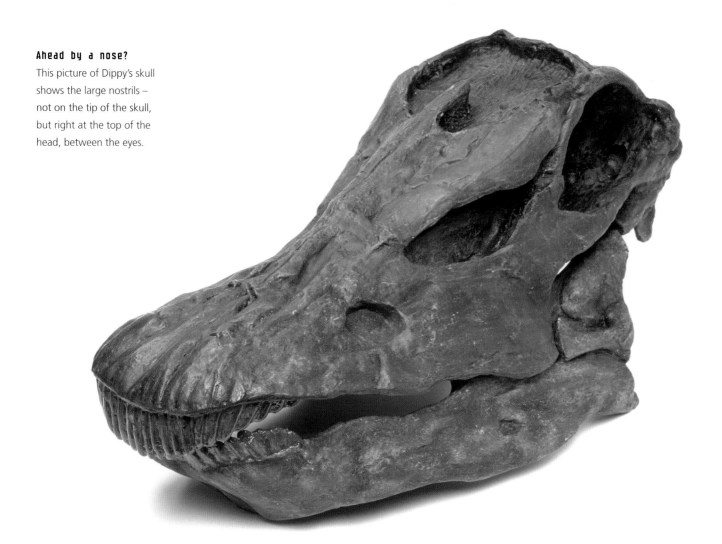

Ahead by a nose?
This picture of Dippy's skull
shows the large nostrils –
not on the tip of the skull,
but right at the top of the
head, between the eyes.

in many respects sauropod skeletons are built like bridges, with the legs acting as columns and the backbone as the span of the bridge. Roughened patches on the bones show that strong muscles and ligaments attached to the vertebrae ran alongside the backbone, adding even more strength. Comparisons with bird skeletons, which have hollow vertebrae very similar to those of sauropods, suggest that these spaces were filled with air sacs, which did lighten the skeleton to some extent. This would not have helped with buoyancy in water however, as the total amount of air would not have been enough to cancel out the effect of a sauropod's massive weight. Nevertheless, the skeleton was lighter than it would have been if the sauropod vertebrae were made of solid bone, and this would have made it easier for the legs and backbone to support weight when on land. Palaeontologists now know that these air sacs formed part of a complex breathing system, which probably worked in the same way as bird lungs and which was also seen in meat-eating dinosaurs like *Tyrannosaurus* and *Velociraptor*. In addition, hundreds of sauropod trackways have now been found around the world. These prove beyond doubt that sauropods walked around on land and also show that many sauropods travelled around together in herds, rather like elephants and antelope today.

Hollow vertebrae
This backbone (vertebra) of the English dinosaur *Ornithopsis* shows the numerous hollows and struts that are characteristic of sauropods.

Living in herds

Lots of evidence, from trackways and from mass graves of sauropods, suggests that many sauropods lived, and died, together.

Other work has shown that sauropods would not have been able to use their long necks as snorkels. Standing in a deep lake, the water pressure acting on a sauropod's chest would have made it impossible for it to breathe in and draw air into the lungs, even if the chest were only a few metres underwater. However, palaeontologists still do not understand why sauropods had their nostrils on the tops of their heads. It may be that this was to protect the delicate nasal membranes when the sauropods pushed their snouts into trees and bushes to get a mouthful of food. Studies of the teeth and jaws have shown that many sauropods had teeth that were ideally suited for slicing through tough plant matter. The teeth are often worn down to give them very sharp edges that would have acted as shears, allowing them to chomp through all but the woodiest stems and leaves. Sauropods did not chew their food well and would have swallowed their mouthfuls of food almost immediately. This is because they did not have cheeks – cheeks are needed to keep food in the mouth during chewing. However, their massive barrel-shaped bodies would have housed enormous guts that would have been able to break down this poorly chewed fodder. Some sauropods also swallowed stones, called gastroliths, which helped to grind up food in the stomach. Sauropods would not have needed to rely on soft weeds and algae – they could have eaten a wide variety of plant food. As a result of this new evidence, most palaeontologists now think that sauropods spent most of their time living on land, though they probably entered water from time to time in order to bathe or simply to cross rivers or lakes to reach new feeding grounds or breeding areas. When originally mounted, Dippy's neck pointed downward so that the head was close to the ground. In the 1960s the neck was raised into a horizontal position, reflecting the evidence that it browsed from the tops of tall trees.

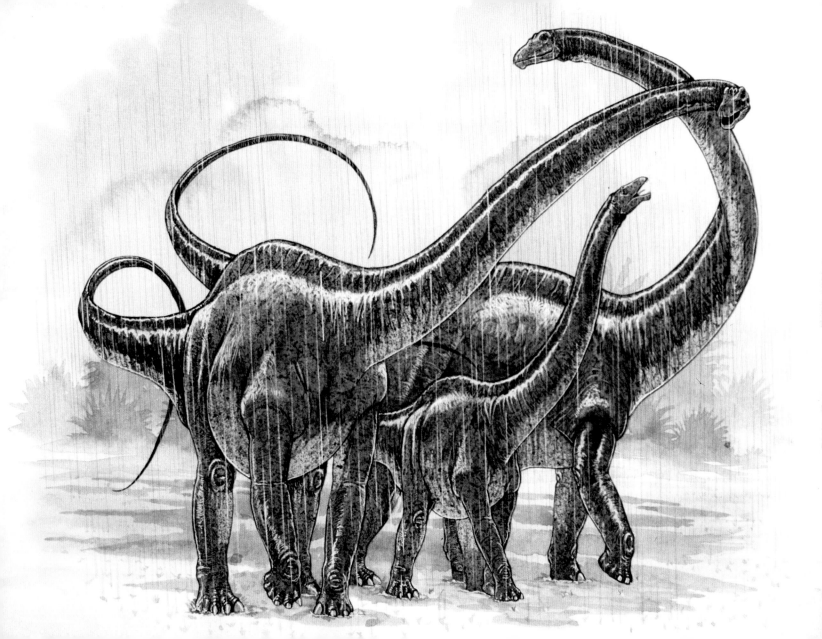

An odd sauropod

In *Diplodocus* and some of its close relatives, the vertebrae at the end of the tail are narrow and cylindrical. They form a long whip-like structure that might have been useful for defence.

Sauropods were bizarre animals, by any standards. However, *Diplodocus* and its closest relatives (*Apatosaurus*, *Barosaurus*, *Brontosaurus* and *Tornieria*) were particularly unusual. The skull was long and low, with similar proportions to a horse's head and the front of the jaws were broad and square-ended, rather than rounded or 'v'-shaped as in all other dinosaurs. *Diplodocus* and its relatives also had strange, pencil-like teeth that would not have been capable of chewing or slicing food, unlike the teeth of other sauropods. The teeth were bunched together at the front of the mouth, forming a comb- or rake-like structure that stuck out from the jaws at an awkward angle. It is thought that *Diplodocus* used this comb of teeth to strip leaves from branches, by grasping a branch in its mouth and then pulling its head back while the jaws were clamped around the stem. The front legs were also quite unusual – they are much shorter than the hind legs, with the result that the chest was carried much closer to the ground than in other sauropods. Finally, the tail is exceptionally long and ends in a section made up of many small, tube-like vertebrae. This part of the tail is called the 'whiplash' and some scientists have suggested it could have been used as a weapon. *Diplodocus* might have defended itself from attacks by meat-eating dinosaurs, such as *Allosaurus* (whose remains have been found in the same rocks), by swiping at its enemies with its powerful tail. It's even been suggested that the tail may have made a noise like a cracking whip.

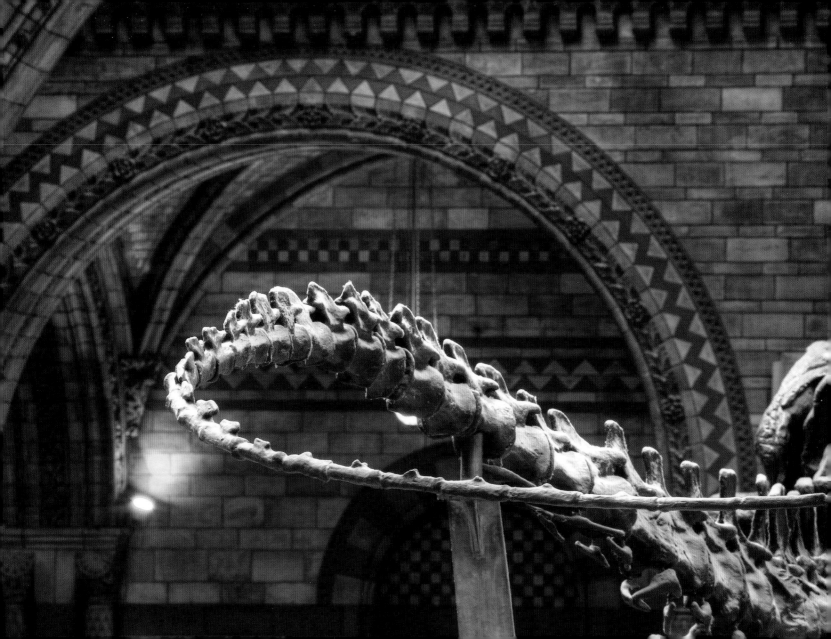

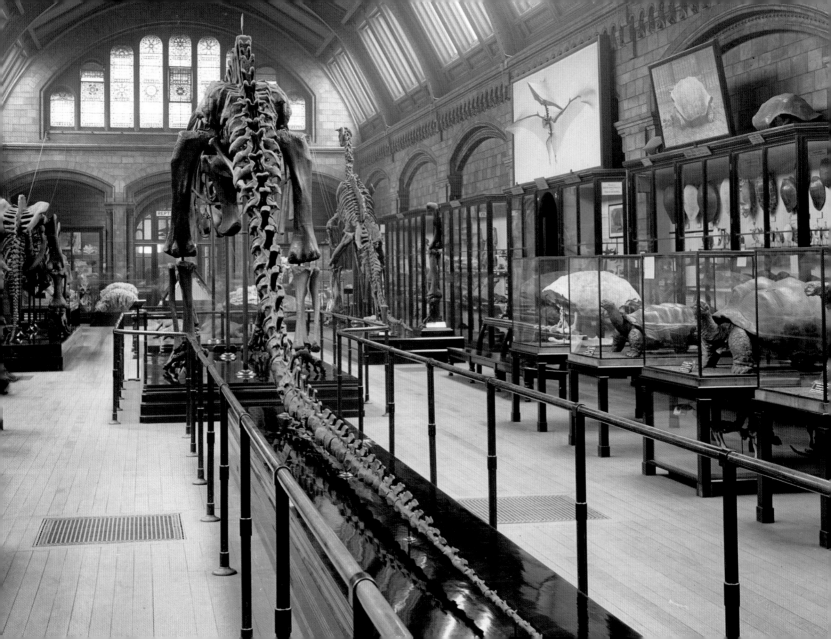

New discoveries

Although the remains of *Diplodocus* have been known for over 120 years, scientists continue to find new ways to study this remarkable animal and there have been many exciting discoveries. Some of these are the result of applying new techniques to bones in museum collections, whereas others have resulted from unearthing new specimens of *Diplodocus* from the Late Jurassic rocks of Wyoming and Colorado. Some of these discoveries have led to important changes in Dippy's appearance. For example, work on dinosaur walking showed that the tails of these animals did not drag along the ground, as had been assumed for many years, but stuck out straight behind the animal, held clear of the ground. In 1993, Dippy's tail was remounted to reflect this new research – the tail curved gracefully above the heads of visitors, who could walk underneath and gaze up at the intricate detail of its tail-bones. A new skeleton discovered in Wyoming in 1990 also showed that *Diplodocus* possessed a row of armour along its back. The armour was made up of small cone-like pieces of bone and may have been for defence or display. Although many other *Diplodocus* skeletons had been found before, this was the first time that anyone had found any armour. Our picture of *Diplodocus* and its relatives may have to change as a result.

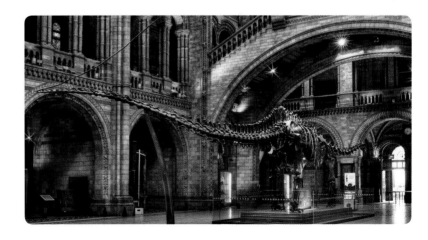

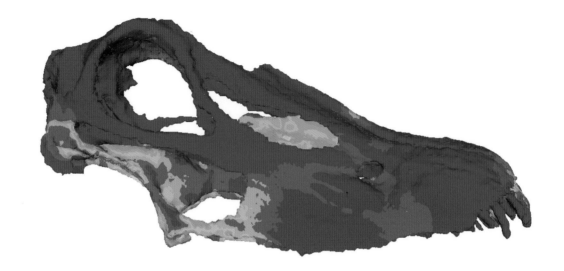

Stress and strain

Computer models of the skull of *Diplodocus* are beginning to show how this animal ate its food while it was alive. The colours represent the different strengths of forces acting on the bones of the skull, with cool blue colours being low and warmer colours being high.

Up, down or sideways?

New work on the neck of *Diplodocus* has shown that it was very flexible. These virtual models of the neck (opposite) allow scientists to test the movements without having to move the very heavy, fragile bones.

Advanced computer technology has also been used to try to reconstruct the behaviour of *Diplodocus*. Computer modelling of the neck bones showed that it was capable of moving the neck through a wide arc, both from side-to-side and up-and-down. This would have meant that *Diplodocus* could have reached food high among the tree-tops, as well as allowing it to harvest the bushes and trees on either side. As a result, *Diplodocus* would have been able to get a good meal just by standing on the spot and eating everything within reach – it would not have had to waste a lot of energy on moving about too much. In addition, detailed computer-based studies on the skull are showing how *Diplodocus* used its teeth and jaws. This includes information on its bite strength, which is giving clues about the sorts of plants it may have eaten.

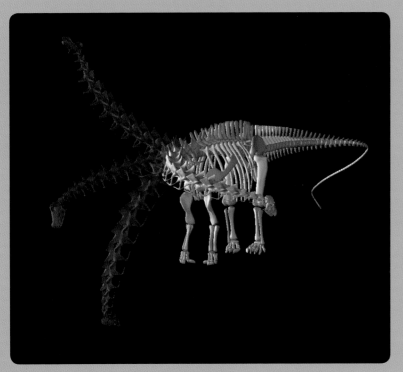
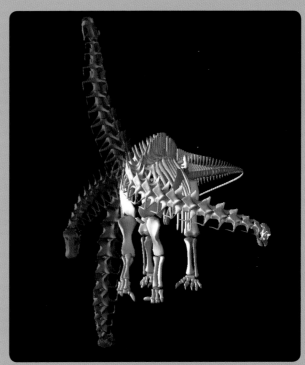

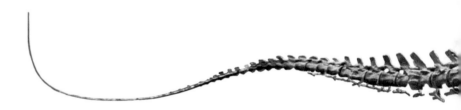

The Future of Diplodocus

Continuing work on *Diplodocus* and other sauropods is likely to yield many more surprises in the future. New technology will allow us to probe into their remains in more detail than Carnegie, Marsh, Hatcher or Holland could ever have imagined. Finds of more skeletons will also give scientists better opportunities to learn about the lifestyle of this famous animal. Some of this research may even force the Natural History Museum to update Dippy's posture or pose in the future.

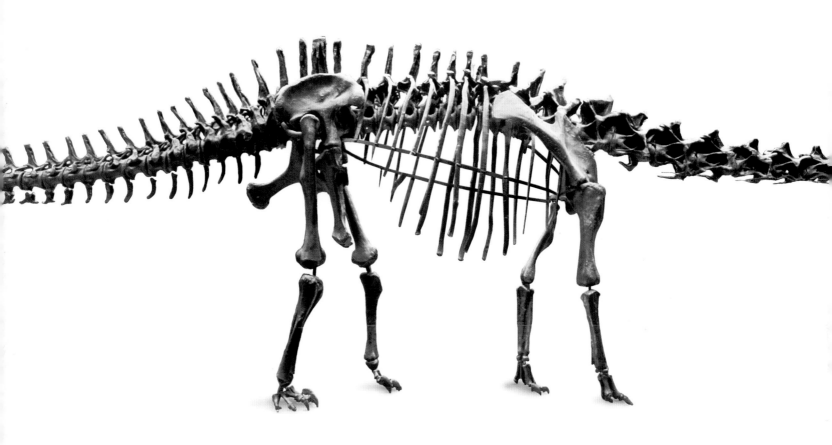

Further information

Books

Bone wars: the excavation and celebrity of Andrew Carnegie's dinosaur, T. Rea. University of Pittsburgh Press, 2001.

Dinosaurs, D. Naish and P.M. Barrett, Natural History Museum, London, 2016.

Dinosaurs: A very short introduction, D.B. Norman. Oxford University Press, 2005.

National Geographic Dinosaurs, P.M. Barrett. National Geographic Society, 2001.

The Illustrated Encyclopedia of Dinosaurs, D. Dixon. Lorenz Books, 2006.

The Natural History Museum Book of Dinosaurs, T. Gardom and A.C. Milner. Carlton, 2006.

Websites

http://www.carnegiemnh.org/dinosaurs/

http://www.nhm.ac.uk/discover/dino-directory/index.html

Picture credits

pp.8-9 © Istockphoto; p.11 © Paul Barrett; p.15 © John Sibbick/NHMPL; p.19 Courtesy of Carnegie Museum of Natural History; p.23 Courtesy of Carnegie Museum of Natural History; p.30 Courtesy Museo de la Plata, Argentina; p.31 © C P Castell / NHMPL; pp.39 © De Agostini/NHMPL; p.44 © Dr Mark Young / Dr Emily Rayfield; p.45 © Kent A. Stevens. All other images © NHMPL (Natural History Museum Picture Library). Every effort has been made to contact and accurately credit all copyright holders. If we have been unsuccessful, we apologise and welcome correction for future editions and reprints.

Acknowledgements

Thanks to the following for fact checking, access to unpublished information, photography and the sourcing of images: Derek Adams, Bernadette Callery, Patricia Hart, Paul Lund, Mindy McNaugher, Angela Milner, Kent Stevens, Emily Rayfield and Mark Young.